THIS NOTEBOOK
BELONGS TO:

ERNEST CREATIVE DESIGNS

Copyright © 2019.
All right reserved. No part of this book or this book as a whole may be used,
reproduced, or transmitted in any form or means
without written permission from publisher.

LETTERS

A B C D E F G H I J
K L M N O P Q R S T U V
W X Y Z

NUMBERS

0 1 2 3 4 5 6 7
8 9 10

0

ZERO

1

ONE

2

TWO

THREE

5

FIVE

6

SIX

7

SEVEN

EIGHT

10

TEN

SHAPES

SQUARE

CIRCLE

HEART

ELLIPSE

ARROW

RECTANGLE

RINGE

STAR

TRIANGLE

SEMICIRCLE

RHOMBUS

PENTAGON

ANIMALS

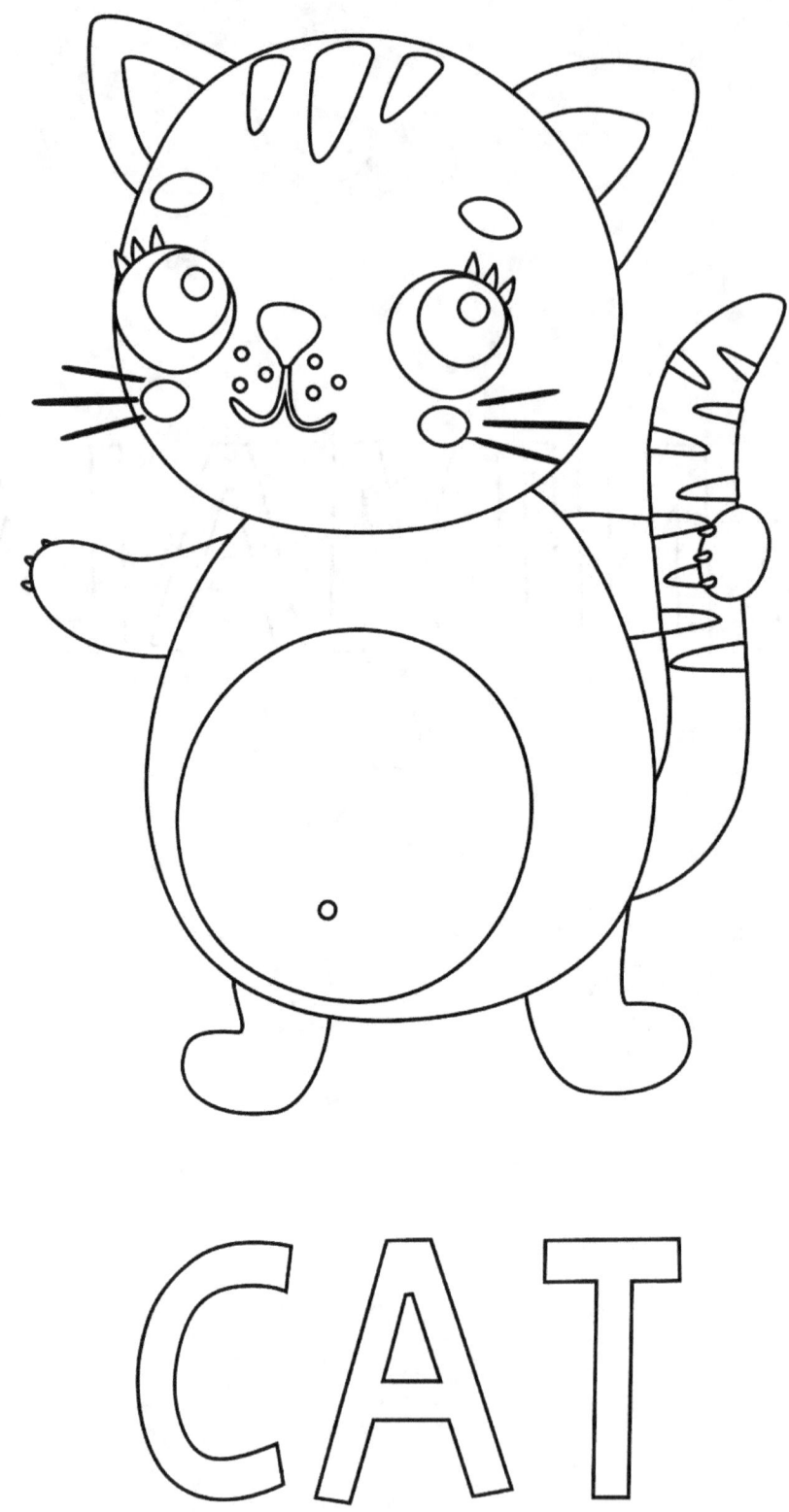

CAT

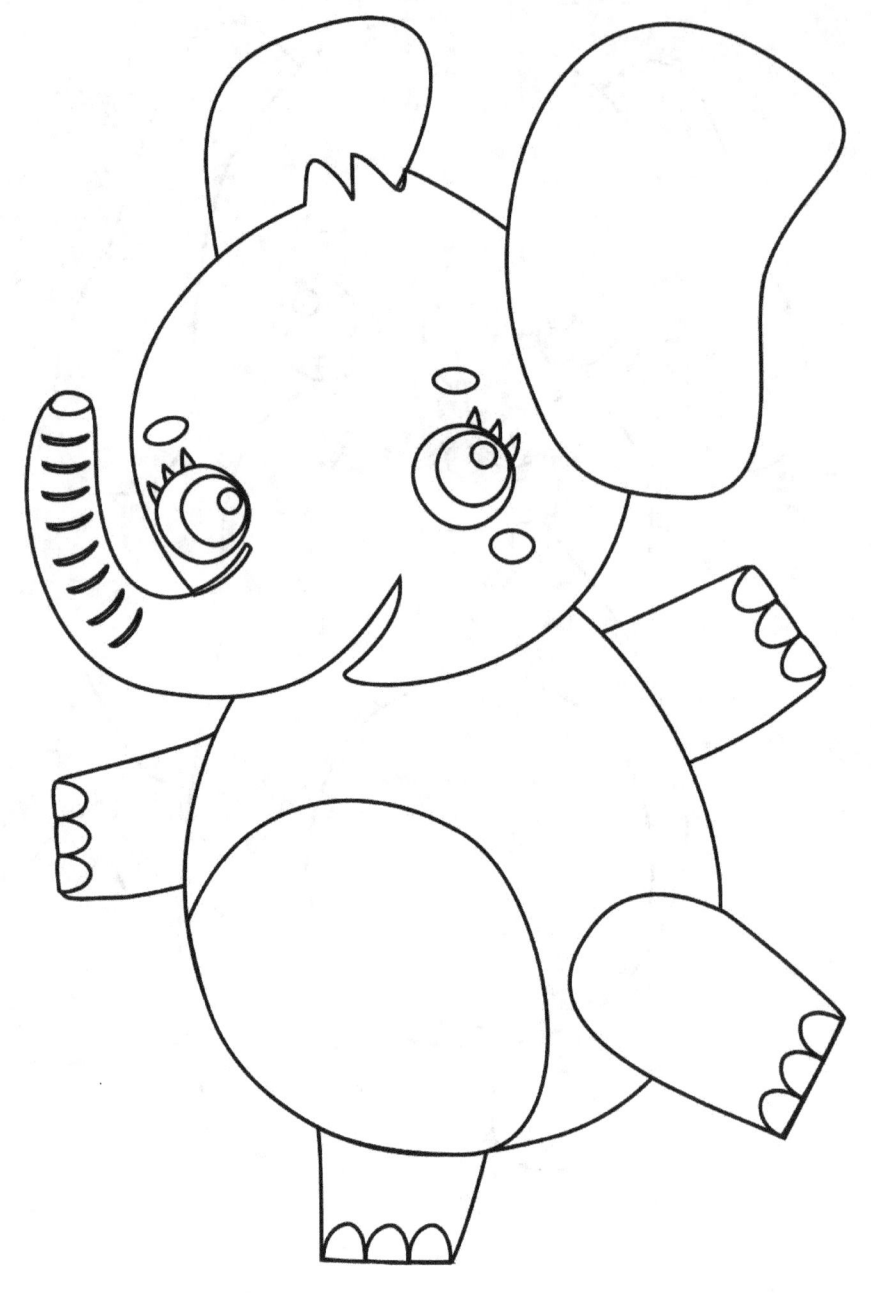

ELEPHANT

FOX

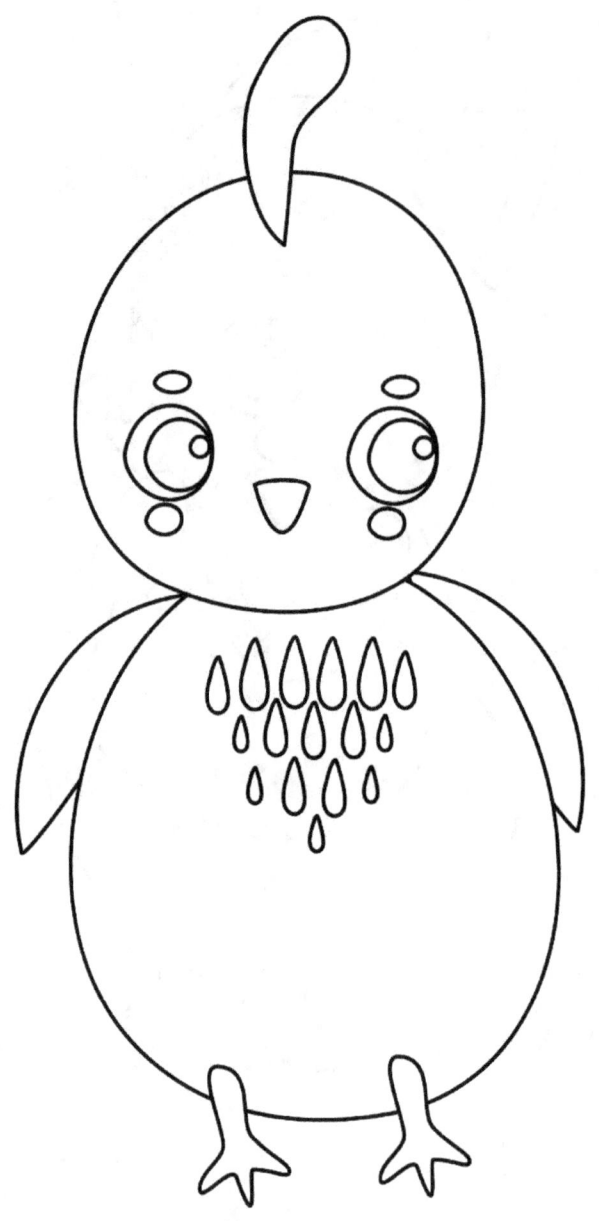

CHICKENS

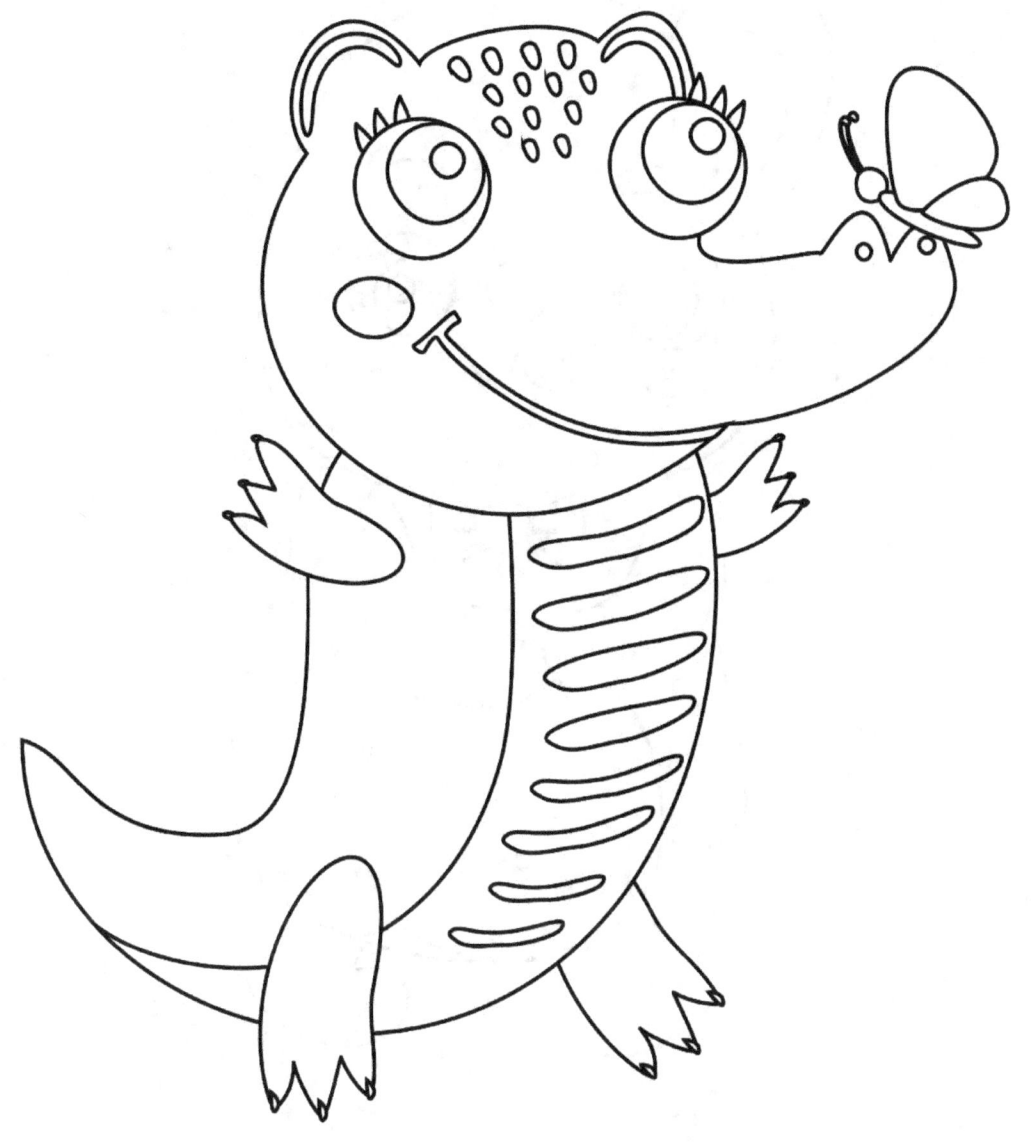

ALLIGATOR

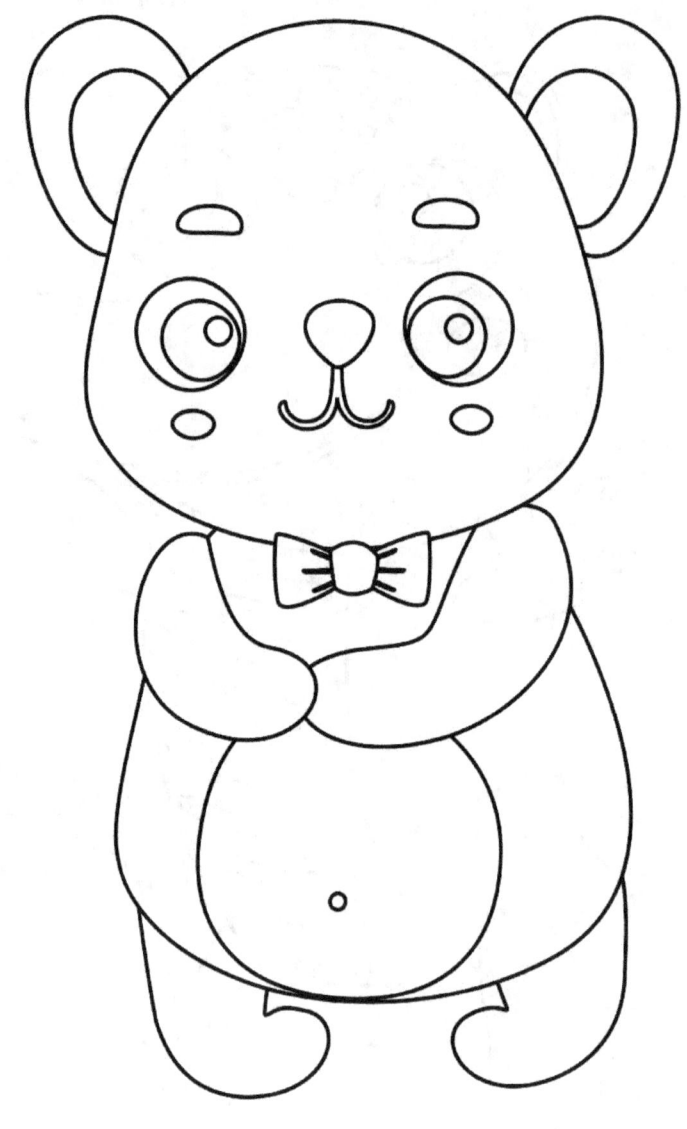

BEAR

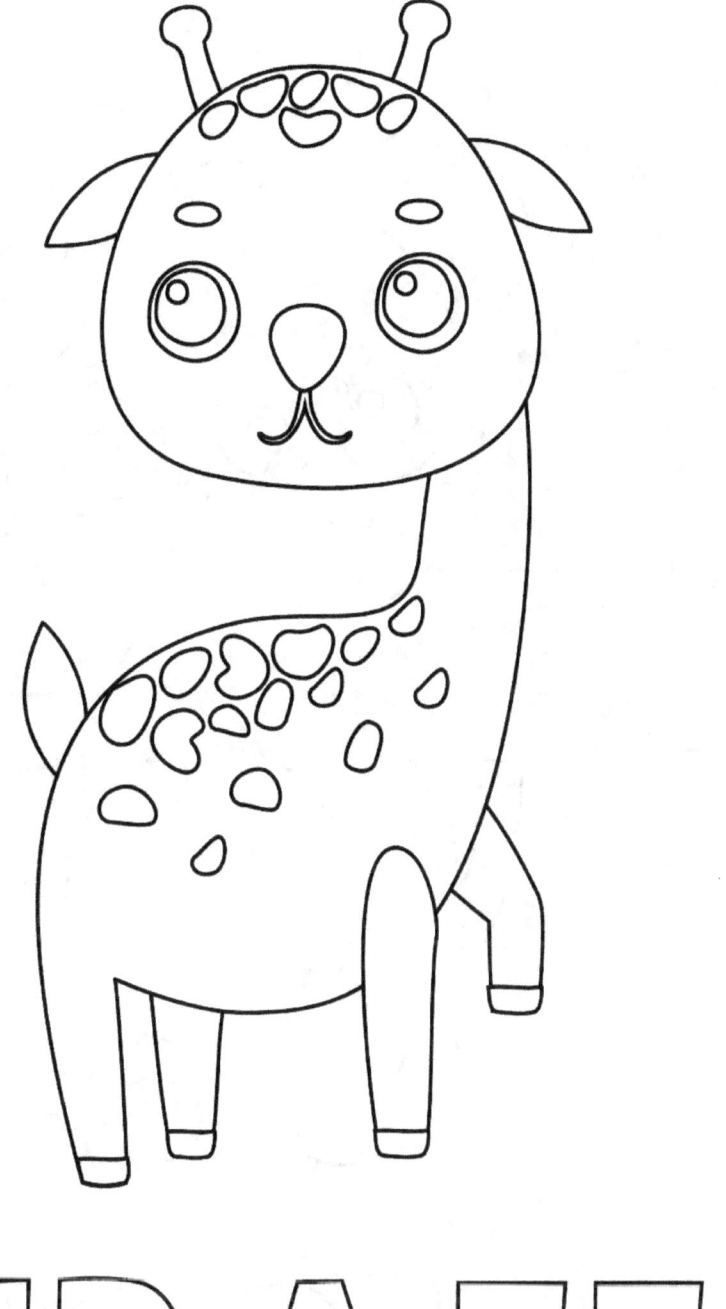

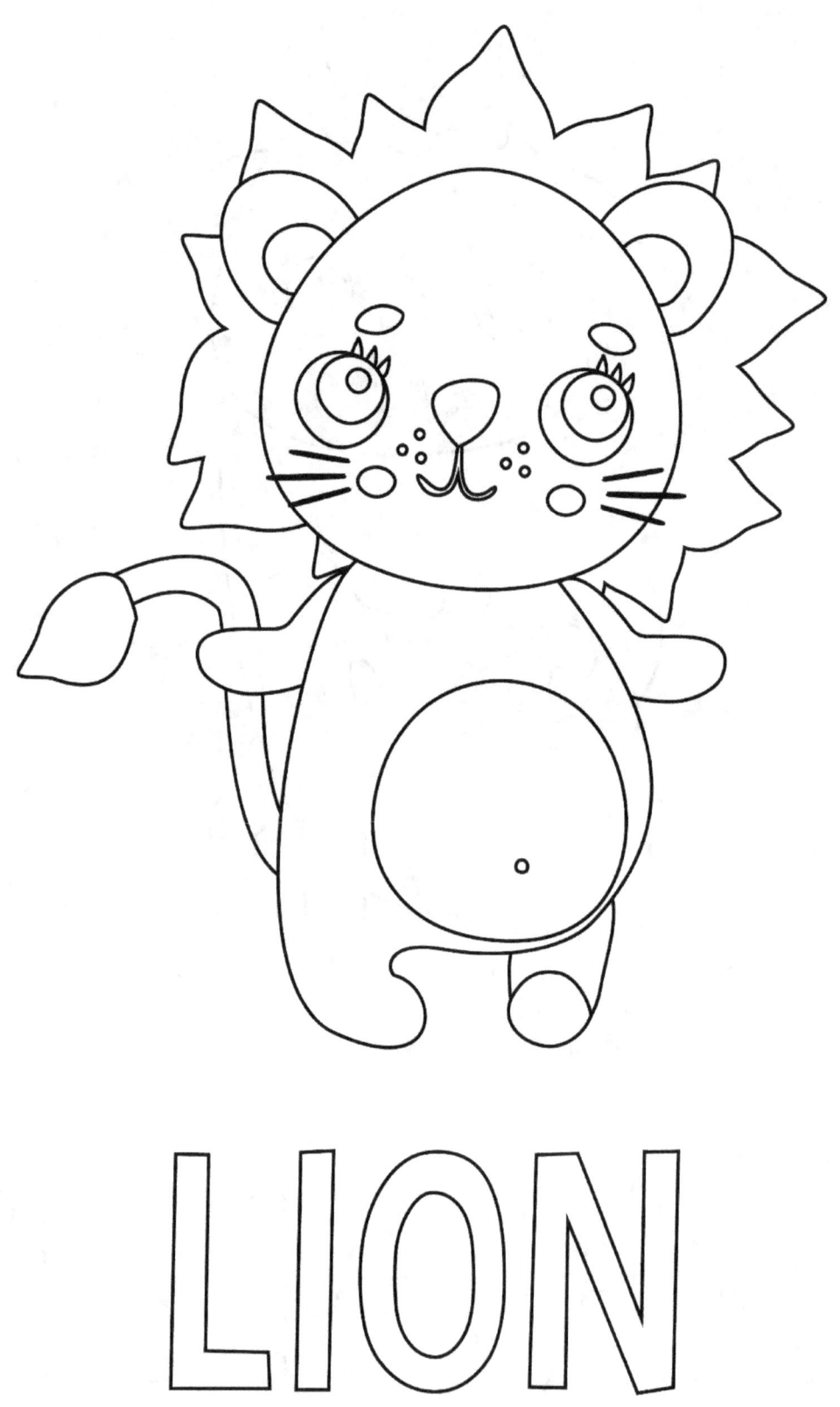

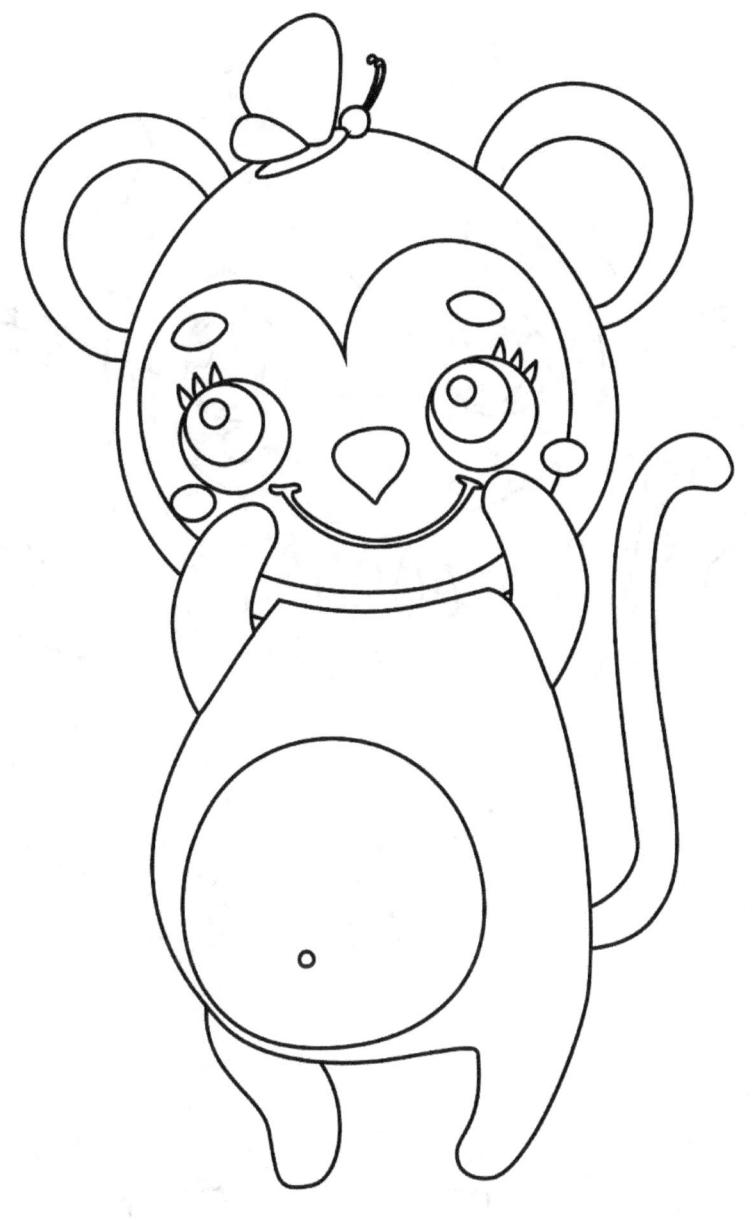

MONKEY

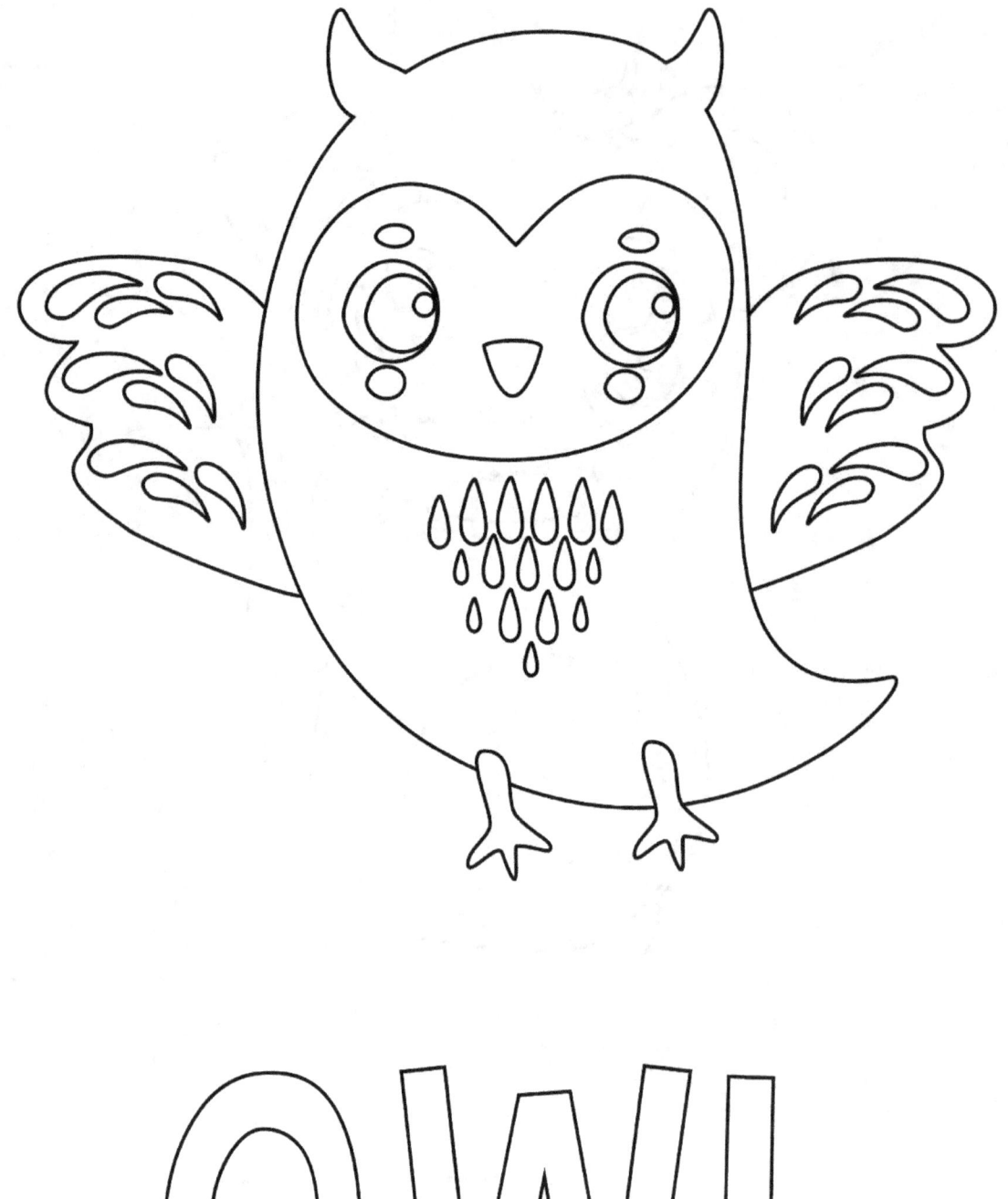

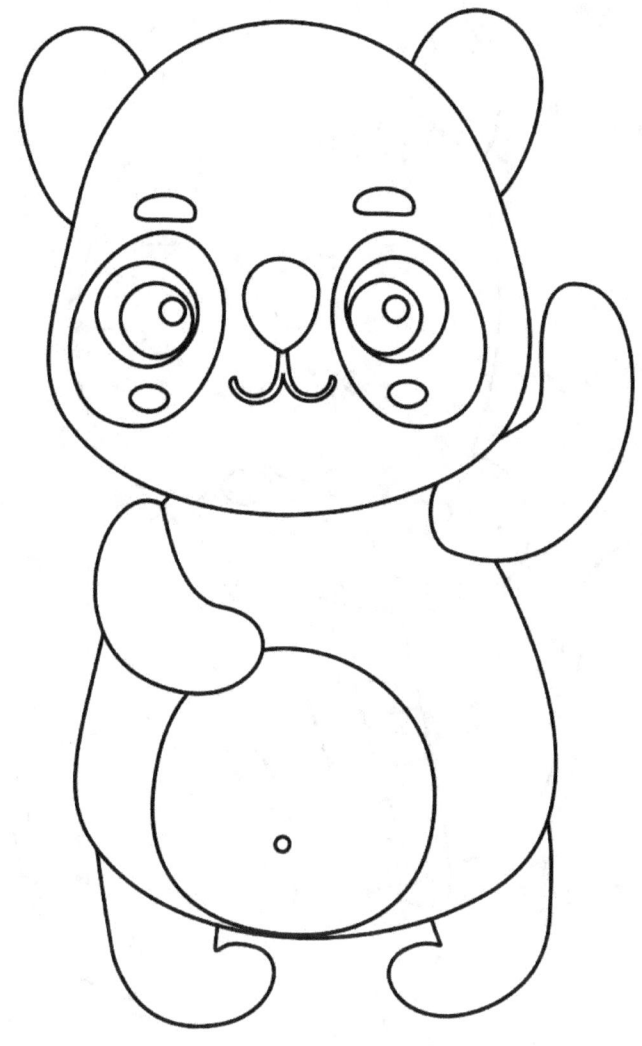

PANDA

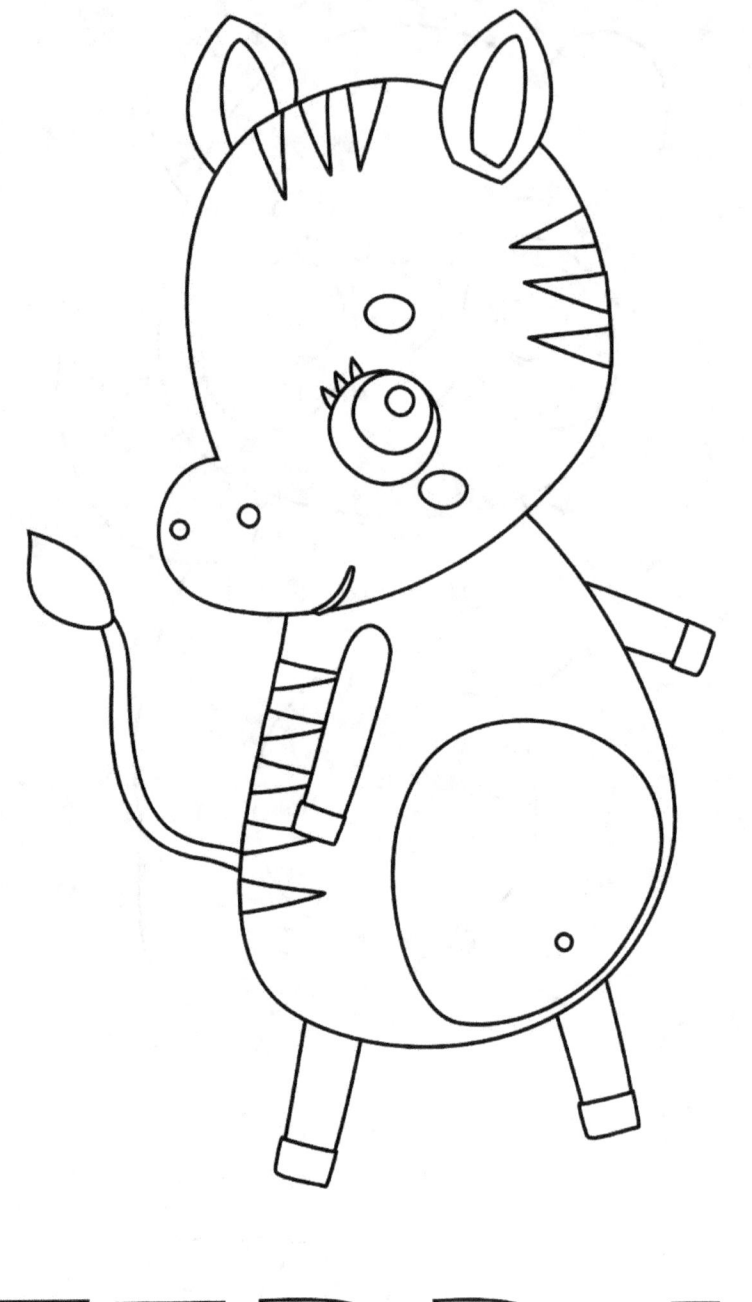

ZEBRA

FOOD

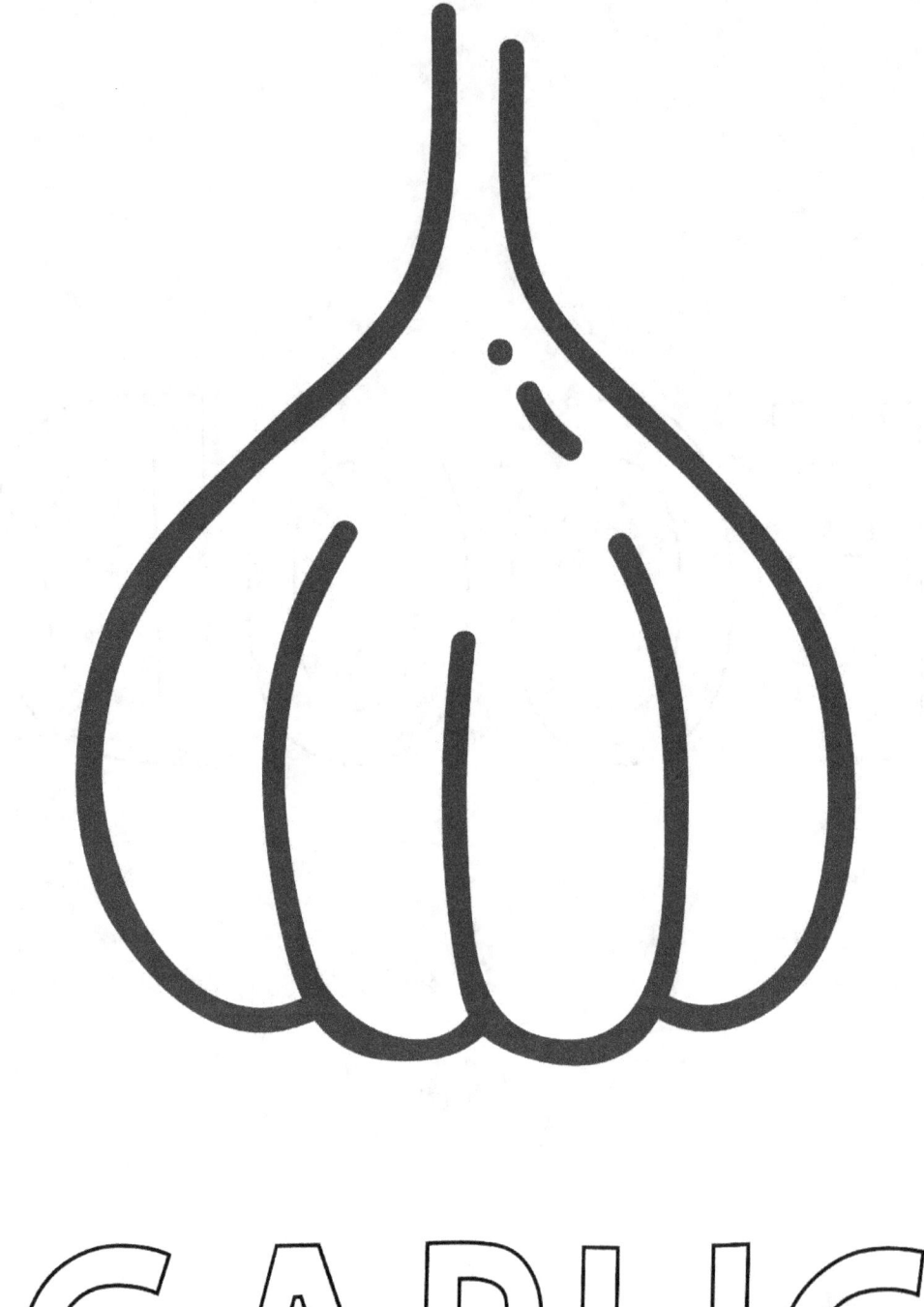

GARLIC

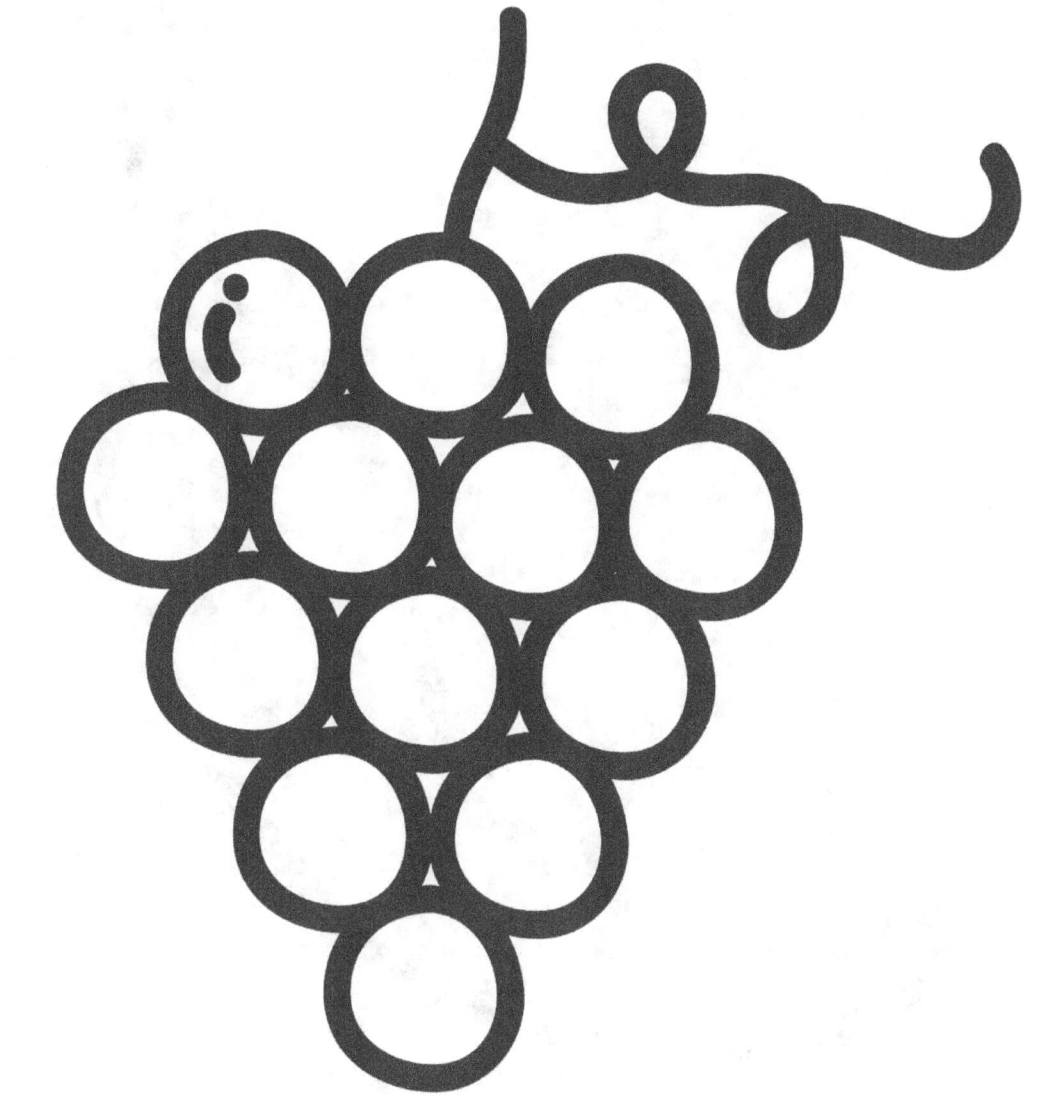

GRAPES

HOT PEPPER

LEMON

MASHROOMS

ONION

PEAR

PUMPKIN

STRAWBERRY

TANGERINE

TOMATO

WATERMELON

BANANA

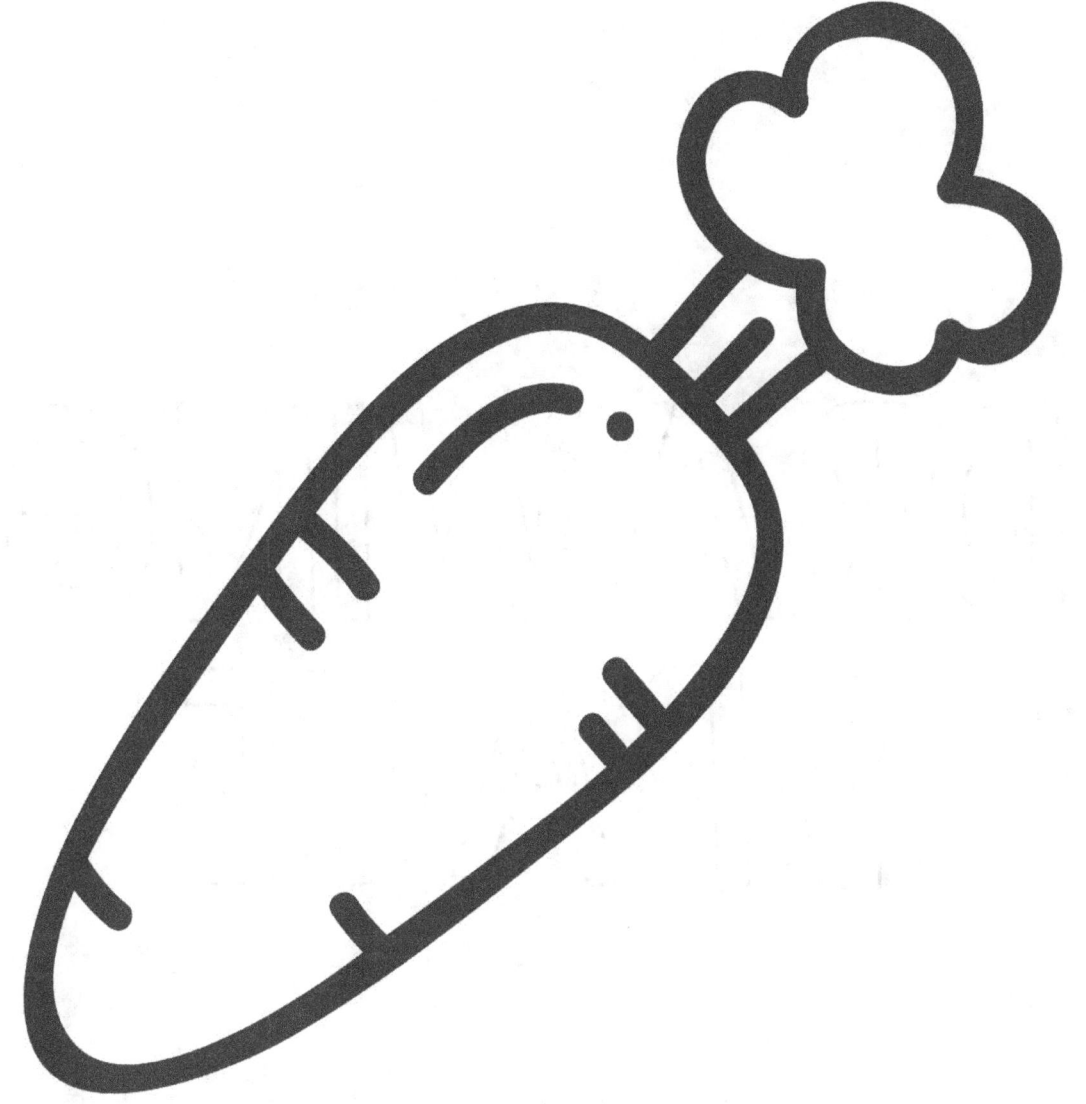

CARROT

DRAWING SPACE

www.ingramcontent.com/pod-product-compliance
Lightning Source LLC
Chambersburg PA
CBHW081449220526
45466CB00008B/2567